IMAGES
of America
STAFFORD COUNTY

IMAGES
of America

STAFFORD COUNTY

De'Onne C. Scott

Copyright © 2005 by De'Onne C. Scott
ISBN 0-7385-1848-4

Published by Arcadia Publishing
Charleston SC, Chicago IL, Portsmouth NH, San Francisco CA

Printed in the United States of America

Library of Congress Catalog Card Number: 2005928460

For all general information contact Arcadia Publishing at:
Telephone 843-853-2070
Fax 843-853-0044
E-mail sales@arcadiapublishing.com
For customer service and orders:
Toll-Free 1-888-313-2665

Visit us on the Internet at www.arcadiapublishing.com

Contents

Acknowledgments 6
Introduction 7
1. Prehistory, Native Americans, and Pocahontas 9
2. George Washington 13
3. Historic Churches 17
4. Civil War 21
5. People 29
6. Places 77
7. Creeks and Rivers 109
8. Stafford's Changing Landscape 121
About the Author 128

Acknowledgments

The people who care so deeply about preserving and recording the history of their families are an important reason the history of our county is preserved and recorded. There are so many of these people to thank for the generous gift of their time, knowledge, loan of their treasured photographs, and for telling their family stories.

I offer my sincerest thanks to David Berreth, Joanna Catron, and Susie Taylor Schran, who were the first to offer whatever I needed from their large archive at Belmont, the Gari Melchers Estate and Memorial Gallery of the University of Mary Washington. Danny Patrick "D. P." Newton of the White Oak Civil War Museum and Stafford Research Center, who is a true steward of our county's history, gave so much help to me. I offer my grateful thanks to the APVA Preservation of Virginia and Josiah P. Rowe of the *Free Lance-Star* newspaper.

Alvin Y. Bandy, Rev. E. T. "Tick" Bourne, Wayne Broyles, Daniel M. Chichester, Sandra Chinn, Mr. and Mrs. Milton S. Christy, Eileen Shelton Greene, Denise N. Hardy, Shirley Heim, the Honorable and Mrs. William J. Howell, Douglas F. Jones, Janet C. LeCouteur, James Macintosh, Peter A. Nuccio, Charles W. Payne Jr., Charles "Togie" Payne, Joann Payne, Marian B. Robinson, Margaret T. Scott, Lou Y. Silver, Dorothy Simpson, Wayne W. Skinner, and Joyce W. Sterne deserve as much appreciation as I can show for lending their photographs, sharing their personal family stories, and helping me make photograph connections.

My daughters, Desa and Cary, deserve thanks for listening patiently to my many concerns over the six months allotted to put this book together. My mother, Ruth, who shared her love of history with me, deserves thanks because the seed she sowed finally bloomed. In the end, my greatest thanks goes to my husband, Paul, without whose support, encouragement, proofreading skill, photograph-gathering skill, and knowledge of the people and places in Stafford County, this work could not have been done.

During the process of collecting photographs for this work, what impressed me most was the pure desire of these people to preserve Stafford County's history. I offer my sincere appreciation to all who helped me in this work and hope I will be able to give the same help to those who are also compelled to seek out and preserve our local history.

INTRODUCTION

Millions of years of evolution have brought us to the Stafford County we know today. Long before this area became one of America's oldest counties, complex cultures thrived here. John Smith discovered present-day Stafford County on his trip up the Potomac River. George Washington and George Mason, who moved to Stafford in their youth, helped shape our nation. America's Civil War left scars on Stafford that took more than a century to heal. Stafford's landscape has changed much since it was formally established in 1664. Looking back through Stafford's history reveals some of the people, places, and events that contributed to our national history.

The fossilized plants and animals found in Stafford hint about the pre-history of the area. The sauroposeidon, the longest dinosaur found in Virginia, lived here. Other previously unknown prehistoric animals and plants have also been found.

The Patowomecke (Potomac) and Manahoac Indians thrived here long before Jesuit priests came to Stafford County. John Smith found a Patowomecke village during explorations on the Potomac River and Potomac and Aquia Creeks. Pocahontas was sent to present-day Stafford County on Potomac Creek by her father, Powhatan. Capt. John Argall discovered her there and gave "a copper and kettle and other trifles" to Japazaws, chief of the Patowomecke Indians in the village at present-day Indian Point for his help in getting Pocahontas to board Argall's ship. Local residents have learned firsthand about the early Native American populations in Stafford County through the discovery of thousands of projectile points and pottery shards in the fields and near the waterways.

The Brents of Maryland established the first English Catholic settlement in Virginia, on Aquia Creek. When it was opened to all faiths, this became one of the first examples of religious tolerance in Virginia. Among the historic churches locally, one stands apart. Aquia Episcopal Church, built in 1751, is the oldest Episcopal church in America and is nearly in its original form.

George Mason and George Washington, men important to our nation's development, moved to Stafford. Mason, whose early education included tutelage by Rev. Alexander Scott of Aquia Church, wrote the Virginia Bill of Rights and the Virginia Constitution, two documents that set the standard during the formation of our democracy. Washington, our nation's first president, spent his formative boyhood years in Stafford County. He was educated and learned surveying here. Washington's legendary coin toss across the Rappahannock River occurred at his home, Ferry Farm. Parson Mason L. Weems's story of Washington hacking his father's cherry trees was also to have happened there. Other important Stafford residents include R. H. L. Chichester, chief justice of the Virginia Supreme Court; his grandson, state senator John H. Chichester; and delegate William J. Howell, current Speaker of the Virginia House of Delegates.

The Potomac and Rappahannock Rivers, which border the county, played important roles in Stafford County's history. These rivers were sources of energy and transportation for the tobacco plantations, iron works, and flourmills. James Hunter's Iron Works, one of the major industrial plants in the Revolutionary era, supplied the Continental Army with arms and equipment in America's fight for independence. The federal government purchased Brent Quarry on Luck's Island on Aquia Creek in 1791 to provide the stone for the White House and the U.S. Capitol.

Because of Stafford County's strategic location and good transportation networks, it became the staging ground for many area campaigns during the Civil War. Like many homes, Chatham Manor became a Union headquarters and hospital during the war. Chatham was just across the Rappahannock River from the city of Fredericksburg. During the Civil War, many well-known people visited Chatham, including Walt Whitman and Clara Barton. The two Battles of Fredericksburg took place just across the Rappahannock River in December 1862 and April 1863. Union general Ambrose Burnside bogged down his army on the famous "Mud March" through Stafford. During the Union encampment around Stafford County Courthouse, troops destroyed or took many of the county land records. Reluctantly hosting the Army of the Potomac from 1862 to 1863, the civilians of Stafford suffered the destructive effects of war. More than 100,000 men camped here and had to be fed and warmed, straining the county's resources to the point of collapse.

Stafford County's Anthony Burns was the subject of America's first major fugitive slave case. Nationally known Southern abolitionist Moncure Conway led his family slaves to freedom in Yellow Springs, Ohio, in 1862. John Lee Pratt bought Chatham Manor in 1931. Pratt became one of the richest men in America. He worked for E. I. du Pont de Nemours and Company, Inc., and later became vice president of General Motors. The Pratts donated their collection of Fabergé eggs to the Virginia Museum of Fine Arts in Richmond and Chatham Manor to the National Park Service.

Gari Melchers, who was primarily a portrait artist and internationally famous from the late 1800s, came to live in Stafford after purchasing Belmont in 1916. His works are in museums around the United States and the world. The Smithsonian owns *The Sermon*, which was the first painting for which Melchers gained notoriety. Two of Melchers's murals decorate the Library of Congress in Washington, D.C., and the Freer Gallery owns Melchers's portrait of Teddy Roosevelt. Melchers painted many of the local people in their everyday rural lifestyles, as well as many homes and landscapes around Falmouth, Stafford, and Fredericksburg in the stone studio he had built on his Belmont Estate. His wife, Corinne, deeded their Belmont Estate, most of its furnishings, decorative arts, and the remainder of Melchers' paintings to the Commonwealth of Virginia in 1945 for a memorial and art center to honor her husband.

After Interstate 95 was built, travelers bypassed U.S. Route 1, and many of the privately owned businesses along the corridor in Stafford County closed. In the 1970s, a dramatic change in the landscape began after developers took advantage of the vast undeveloped rural real estate and people began moving into the county that was between the nation's capital in Washington, D.C., and the state capital in Richmond, Virginia. Family-owned businesses were replaced with chains, including grocery stores, hotels, banks, fast-food restaurants, and car dealerships, sustained by large, new subdivisions, which continue to consume the old landscape.

The county we know today is far removed from the place roamed by dinosaurs or home to Native Americans. We can only appreciate how far we've come by looking back to the places and the people who made Stafford County what it is today. The images in this book are presented alphabetically within each chapter by subject.

One
PREHISTORY, NATIVE AMERICANS, AND POCAHONTAS

These prehistoric oyster shells, which measure seven inches in length, and turritella shells were found on the banks of Potomac Creek. Sea and land creatures flourished in Stafford County long ago as evidenced by the various types of fossilized shells that can be gathered along the shorelines of Potomac Creek and the Potomac River. Fossils dating back to the Eocene Era, including 118 species of sharks, rays, fish, reptiles, birds, and 9 types of plants, have been found. Of these, one plant, one lizard, and two fish specimens were previously unknown. Dinosaur tracks have also been found locally. (Paul and De'Onne Scott Collection; photograph by author.)

MAKO SHARK	GREAT WHITE SHARK	SAND SHARK	TIGER SHARK
LEMON SHARK	HEMIPRISTIS	EXTINCT SAND SHARK	DUSKY SHARK
BULL SHARK	WHALE TOOTH	BARRACUDA	STING RAY TOOTH PLATE

These fossilized teeth from a bull shark, whale, barracuda, stingray, lemon shark, hemipristis, extinct sand shark, dusky shark, mako shark, great white shark, sand shark, and tiger shark were found along the shores of Potomac Creek. (Paul and De'Onne Scott Collection; photograph by author.)

Paul T. Scott found these Native American points (except the darkest) on Aqua-Po Beach at low tide in the 1950s. The largest points are pre-forms, which were used in making spearheads. The smaller points are arrowheads used for taking big game. Scott's boyhood friend gave the darkest point, of unknown origin, to him. Aqua-Po Beach got the name because it is located at the point where Aquia Creek meets the Potomac River. (Photograph by author.)

Paul T. Scott found the Native American points shown in this photograph in freshly plowed fields and along the shore of Aquia Creek at low tide in Stafford County in the 1950s. These points give testimony to the Native American population in Stafford. Although there is well-documented early history and archeological evidence, Stafford's Patowomecke or Potomac tribe has yet to gain state and national recognition. Approximately 1,500 people living in Stafford in 1995 believed they were descended from the Potomacs. (Paul T. Scott Collection; photograph by author.)

Scott found these Native American pottery shards on the beaches at Thorny Point and Aqua-Po. He found the Colonial clay pipe pieces in nearby plowed fields in the 1950s. (Paul T. Scott Collection; photograph by author.)

In 1611, while visiting what is today, Marlborough Point on Potomac Creek, Capt. Samuel Argall persuaded Japazaws, brother of Powhatan and chief of the Patowomecke Indians, to help him get Pocahontas to board his ship. In exchange for Japazaws's help, Argall gave him a copper kettle and other trinkets. Argall then took Pocahontas back to Jamestown. (APVA Preservation Virginia; author's collection.)

John Smith traveled up the Potomac River where he found beauty and abundance. He discovered the "King's House of Potowameke" near Aquia Creek and the "King's House of Japazaws" at the head of Potomac Creek. Where Falmouth is today, Smith came upon the Accoquecks, who lived on both sides of the Rappahannock River. Richard Featherstone, a man in Smith's party, died and was buried near "Clairbournes run," becoming the first white man to be buried in Stafford. (APVA Preservation Virginia; author's collection.)

Two

GEORGE WASHINGTON

George Washington's father, Augustine, moved his family to Stafford in 1738 when George was six. Washington received his education and grew to manhood in Stafford. He became adjutant of Virginia's Southern District at age 20, a major at 21, and lieutenant colonel at 22. He served in the House of Burgesses, led Virginia's opposition to British Colonial policies, became delegate to the first and second Continental Congresses, and was named to command the Continental Army. He led the Virginia delegation at the Constitutional Convention and was unanimously elected its presiding officer. After the Constitution was approved and ratified, he became the first president of the new United States of America in 1789. (Artvue Post Card Company, New York, New York; author's collection.)

FIRST PORTRAIT OF GEORGE WASHINGTON BY C. W. PEALE

As a child, George Washington, according to Parson Weems, threw a Spanish dollar across the Rappahannock River from his boyhood home at Ferry Farm to Fredericksburg. During Washington's birthday celebrations at Ferry Farm, youngsters reenact his famous coin toss. (Louis Kaufmann and Sons, Baltimore, Maryland; author's collection.)

Parson Weems also told the story that George Washington hacked his father's cherry trees. When asked about the incident, George said he couldn't tell a lie and confessed. This postcard, mailed from Grand Central Station, February 22, 1912, helped perpetuate the legend of Washington's honesty through patriotic glorification. (Author's collection.)

GEORGE WASHINGTON'S SURVEYING OFFICE ON THE WASHINGTON FARM

OPPOSITE FREDERICKSBURG, VA.

The building represented on the postcard is believed to be the only original structure from George Washington's early years at Ferry Farm. Washington is believed to have learned surveying skills around the age of 13 in this structure. (R. A. Kishpaugh, Fredericksburg; author's collection.)

George inherited Ferry Farm upon his father's death in 1743. Mary Ball Washington continued to live at Ferry Farm with her children—George, his three brothers, and sister, Betty—after her husband's death. George Washington surveyed Ferry Farm in 1771. George L. Gordon, Commissioner of Revenue of Stafford County and founding member of the Stafford County Historical Society, made this plat of Washington's survey in 1922. (Photograph by author.)

Three

HISTORIC CHURCHES

Aquia Episcopal Church, in the Overwharton Parish, begun in 1751, survived the Revolutionary and Civil Wars. The only changes to the interior of the church occurred when horses stabled in the church chewed the tops of the pews during its occupation by Union troops. The Aquia sandstone used on the exterior of Aquia Church is from the Brent Quarry on Luck's Island in Stafford as was the stone used for the White House and the east front columns of the U.S. Capitol in Washington, D.C. Benjamin Latrobe, Jefferson's architect for the Capitol, and Pierre L'Enfant, designer of Washington, D.C., traveled to Stafford for stone from the Brent Quarry to use for the Capitol and the White House. The United States acquired Luck's Island in 1791. This undated photograph shows the southern side of the exterior of the Aquia Church and part of the cemetery. (Daniel M. Chichester.)

Berea Baptist Church, located just off U.S. Route 17, was established in 1852. During the Mud March of January 1863, Union troops used the church building as a stable, tore out the gallery and pews, and broke the windows. The church was repaired after the Civil War and the federal government eventually made restitution for the damages. The present walls are original. (Photograph by author.)

Originally organized as Yellow Chapel Church in 1825, it became Hartwood Presbyterian Church in 1868. Here, in February 1863, Confederate brigadier general Fitzhugh Lee's cavalry defeated a Union force, capturing 150 men. The church is listed on the Virginia Landmarks Register and the National Register of Historic Places and is an American Presbyterian Reformed Historical Site. It is located on U.S. Route 17 near State Route 654. (Photograph by author.)

This undated photograph shows what is believed to be the Church of the Holy Spirit. It was located south of Enon on Truslow Road. (Daniel M. Chichester.)

A new roof appears to be the reason for the construction on the Church of the Holy Spirit in these photographs. (Daniel M. Chichester.)

Only the front façade remains of the Union Church in Falmouth. As part of the town charter in 1727, the trustees were ordered to set aside two acres for a church and cemetery. This brick church was the third church, built after the previous church burned in 1818. Because of the proliferation of religious denominations after the Revolution, it was decided to make the new church a "union church" and so it was used by Episcopalian, Presbyterian, Baptist, and Methodist congregations on rotating Sundays until 1950, when a violent storm destroyed all but the façade. (Photograph by author.)

White Oak Primitive Baptist Church, located on Virginia Route 218 in Stafford, was used as a federal hospital during the Civil War. Services at the church have continued since its establishment in 1789. White Oak Primitive Baptist Church is on the National Register of Historic Places. (R. A. Kishpaugh, Fredericksburg; author's collection.)

Four
CIVIL WAR

Aquia Creek Landing was a transportation center in the 1800s. Steamships and trains delivered supplies and travelers to the terminus on the Potomac River in Stafford. It also served as a major supply base for federal armies from 1862 to 1864. The steamer *New York* is shown. (Library of Congress.)

Clara Barton visited Stafford twice during the Civil War. She nursed at least 12,000 troops at Chatham when it served as a hospital in December 1862. After the war, she founded the American Red Cross and organized a Washington office to account for the missing and dead Union soldiers. (Library of Congress; the Albertype Company; author's collection.)

After John Wilkes Booth shot President Lincoln and escaped, he was hunted, discovered, and killed on the Garrett Farm near Port Royal, Virginia. Booth's body was brought up the Rappahannock River and carried in a wagon pulled by a mule team through White Oak to Belle Plains on Potomac Creek. His body was then loaded on the Union steamer *John S. Ide*, which delivered Booth's body to the Navy Yard in Washington on April 26, 1865. Prior to the end of the Civil War, the federal army held captured Confederates at Belle Plains after the Battle of Spotsylvania. Large numbers of captured soldiers were living there during the last days of the war. (Library of Congress.)

William Fitzhugh built Chatham about 1751. Chatham has had many illustrious visitors, including George Washington, Walt Whitman, and John Marshall, chief justice of the United States, who visited his sister at Chatham. Gen. Irvin McDowell ordered the Horace Lacy family to leave Chatham during the Civil War. Burnside and Sumner used Chatham as their headquarters during the first battle of Fredericksburg. According to Lacy family stories, Gen. Robert E. Lee refused to fire upon Chatham during the Battle of Fredericksburg in December 1862, saying he met, courted, and won his wife, Mary Randolph Custis, the granddaughter of William Fitzhugh, at Chatham. Abraham Lincoln made two trips to Stafford during the Civil War, in 1862 and 1863. He met with General McDowell at Chatham. John Lee Pratt bought Chatham in 1931. The Pratts gave their collection of Fabergé Eggs to the Virginia Museum and willed Chatham to the National Park Service. (Library of Congress.)

Capt. George Armstrong Custer and Gen. Alfred Pleasonton met in Falmouth in April 1863. Falmouth was also the center of activity of Burnside's army. The Honorable Alexander H. Seddon, secretary of war of the Confederacy, was a citizen of Falmouth. (Library of Congress.)

Soldiers and dignitaries pose outside the Army of the Potomac headquarters post office near Falmouth, Virginia, in April 1863. More than 100,000 federal soldiers spent the winter of 1862–1863 camped throughout Stafford County. (Library of Congress.)

This pay voucher worth $10 was issued to William Hyland at a camp near Falmouth on May 22, 1863. James Hyland was in Company B, 1st Regiment Artillery of the Connecticut Volunteers. (Paul T. Scott collection.)

On April 17, 1863, General McDowell, with his division of the federal army, arrived on the banks of the Rappahannock River. The retreating Confederates burned the bridge that had connected Falmouth with Fredericksburg. The city capitulated the next day. The Union rebuilt the railroad bridge in six days. The supports were made from pine logs cut from the adjacent forest, shown here from a sketch by Edwin Forbes. (*Harper's Weekly*; Paul T. Scott Collection.)

Fredericksburg in 1862, Just before the Bombardment, and after the Car Bridge was burnt by the Confederate Army.
R. A. Kishpaugh, Fredericksburg, Va

In this image, Fredericksburg is seen from Stafford Heights, just before the 1862 bombardment. Within 15 miles of Chatham, more great armies maneuvered, more battles were fought, more men were engaged in mortal combat, and more officers and privates were killed and wounded than in any similar territory in America. (R. A. Kishpaugh, Fredericksburg; author's collection.)

Abraham Franklin Newton was born in Stafford County in 1842. He joined Company A, 47th Virginia Infantry at age 19. He was listed as absent (sick) for November 1861. He was in Chimborazo Hospital in Richmond from May 2 through 20, 1862. Newton was the brother of William and George and son of Abraham Newton and Catherine Snellings Newton. He applied for and received a pension in Fredericksburg from the State of Virginia on July 3, 1902, age 60, and was given $15 per year because of a disability caused "by a severe pinch by a fellow soldier during the war, and the wound grows worse." He died August 12, 1906, and was buried in the Tabernacle Church Cemetery in Stafford. (White Oak Civil War Museum and Stafford Research Center.)

George Washington Newton joined Company A, 47th Virginia Infantry at age 20. Like his brother, Abraham, George was a laborer when he enlisted May 15, 1861. After developing a fever, he was sent to Chimborazo Hospital on September 16, 1864, and was given a 30-day furlough the next month. He was paroled at Fredericksburg May 6, 1865. The 1910 Stafford County Census listed George as age 70 and as having been married for 43 years to Susan B. Montieth. He died July 4, 1917, and was buried at White Oak Primitive Baptist Church on Route 218 in Stafford. (White Oak Civil War Museum and Stafford Research Center.)

William B. Newton of Company I, 30th Virginia Infantry, formed from Company I, 47th Virginia Infantry, was the brother of Abraham and George Newton and the great-grandfather of Danny Patrick "D. P." Newton. He was a laborer at age 21 when he enlisted July 22, 1861. His shoulder was wounded in action at Drewry's Bluff on May 16, 1864, and he was admitted to Chimborazo Hospital in early April 1865. He was captured there on April 3, 1865, and turned over to a federal provost marshal on April 14, 1865. (White Oak Civil War Museum and Stafford Research Center.)

Charles Roberson (1821–1892) was one of the 23 men from Stafford who joined the Fredericksburg Grays as artillerymen. He fought in the Civil War until wounded. He was able to find his way back home where his wife nursed him back to health. After recovering, he joined the 9th Virginia Cavalry on August 31, 1864. Roberson was captured at the Battle of Saylors Creek and sent to Point Lookout Prison in Maryland just days before the end of the war. He returned to his farm in Stafford in June 1865. He died in 1892 and is buried on his homestead, Hickory Hill. (Lou Y. Silver.)

The 3rd Brigade, 3rd Division, 6th Corps carried off rails and gathered persimmons during their time at Stafford's Store on the road from New Baltimore to Falmouth. Stafford's Store was described by the artist as having a meadow of about an acre attached to it that was entirely surrounded by a rail fence. It was also described as having more "supplies" than other districts and had the sounds of hens, roosters, sheep, and all sounds of a good larder. The federal soldiers pulled up fence rails until the fence disappeared. (*Harper's Weekly*; Paul T. Scott Collection.)

Five
PEOPLE

The singers in the Berea Quartet from Berea Baptist Church included, from left to right, Stacy Raines, Linwood Christy, Milton Christy, and John Ashton Christy, Milton's father. Rena Young played piano for the quartet that performed all around Virginia, sometimes giving three performances a day in different places. Milton Christy was 14 when he joined the group and sang with it for about eight years. He was 18 in this photograph, which dates it to about 1951. (Milton S. Christy.)

William "Bill" Bolton was principal and coach at Falmouth High School in 1936. He left the school system to go to law school. After finishing law school and passing the bar, he became a practicing attorney in Fredericksburg for many years. (Wayne Skinner.)

Mercer and Marvin Boutchyard were brothers who worked on the George Skinner farm on Cool Springs Road for Mr. Skinner in the early 1940s. Both joined the Marines and both were killed at Iwo Jima. (Wayne Skinner.)

The Brooke Baseball Team of 1932 was made up of, from left to right, (first row) Ernest Grigsby, E. Conyers, B. Crismond, W. Lowry, and M. Shelton; (second row) William Gordon Shelton Sr., R. Conyers, H. Fleming, V. Shelton, and H. Payne. (Eileen Shelton Greene.)

St. Clair Brooks (at lower left in the Eton cap) made his first dollar for holding the reins of Pres. Grover Cleveland's carriage horses. The president was visiting Mr. and Mrs. W. Seymour White on Prince Edward Street in Fredericksburg after the unveiling ceremony for the Mary Washington Monument on May 10, 1894. President Cleveland had been the principal speaker for the ceremony. Brooks was a good friend of John Lee Pratt. They enjoyed many long walks together, and it was during one of their walks that Brooks suggested the land along their path should be a park. Pratt later donated the land and stipulated it be named St. Clair Brooks Park. (Marian B. Robinson.)

Daniel McCarty Chichester, a judge in Fairfax County, Virginia, married Agnes Robinson Moncure, daughter of R. C. L. Moncure. They had seven children, including two sons, R. H. L. Chichester Sr. and Daniel McCarty Chichester. (Daniel M. Chichester.)

Agnes Robinson Moncure Chichester, daughter of R. C. L. Moncure, became owner of Glencairne Farm, near Falmouth. She married Daniel McCarty Chichester. (Daniel M. Chichester.)

R. H. L. Chichester Sr. became a Virginia Supreme Court judge and later its chief justice. He owned Glencairne Dairy Farm until his death in 1930 and is the grandfather of Daniel M. Chichester, Stafford County commonwealth's attorney. (Daniel M. Chichester.)

Daniel McCarty Chichester, brother of R. H. L. Chichester Sr., was a farmer until he died at the age of 23 of a blood infection. (Daniel M. Chichester.)

Pictured in this early photograph are R. H. L. Chichester Sr. and his daughter, Mary Wallace. The Chichester family had an old photograph of Liberty Hall (see chapter six), which was the home of Dr. Michael Wallace. (Daniel M. Chichester.)

This early 1900s photograph shows Agnes Robinson Moncure Chichester and six of her seven children. Standing in front of the porch from left to right are (first row) Mary Lewis Chichester, Agnes Robinson Moncure Chichester, and Halley Moncure Chichester; (second row) Frank Moncure Chichester, lawyer; John Conway Chichester, Fredericksburg police sergeant who dumped alcohol in the Rappahannock River during Prohibition; R. H. L. Chichester Sr., who, like his grandfather, was a chief justice of the Virginia Supreme Court; and Cassius Moncure Chichester, law professor. Peyton Moncure Chichester is not pictured. (Daniel M. Chichester.)

This photograph dated September 12, 1915, shows William Conway holding King of Chillmark, bought by Judge R. H. L. Chichester for $150 from V. Everett Macy, founder of Macy's Department Store in New York. Chichester had the bull shipped by train to Fredericksburg. He sold the bull in 1919 for $20,000 and used the money to build a new barn, milk house, and kitchen at Glencairne. (Daniel M. Chichester.)

The Chichester family posed for this late-1940s photograph in the yard of their Glencairne Farm. Richard Henry Lee Chichester and his wife, Van Massey Chichester, are surrounded by their children, Daniel McCarty (sitting on the lap of his father), Richard, and John (at far right). Richard Henry Lee Chichester was commonwealth's attorney for many years. His son Daniel followed in his father's footsteps as commonwealth's attorney of Stafford County as well. John became a Virginia state senator. (Daniel M. Chichester.)

Alice, Esther, Robert, Harry, and James Chinn pose from left to right with their horses on the Chinn Farm (south side of White Oak Road) about 1910. The Chinn Farm was across from the Fines Farm, which was their "Uncle Tom's Farm." Present-day White Oak Road exists where the long, white fence ran. Union troops camped all around the Fines Farm during the Civil War. Harry Chinn became a soldier during World War I. The Fines home still stands today though the barns are gone, replaced by the White Oak Volunteer Fire Department, located behind the Fines home. (Sandra Chinn Hammond and Janet Chinn LeCouteur.)

Janet Chinn posed with her brother and their cows, Big Fan and Buttercup, in the yard of the Chinn Farm on White Oak Road across from the Fines Farm and White Oak Fire Department. The Chinn farmhouse had cypress siding, which is one reason it has remained in such good repair. (Janet Chinn LeCouteur.)

James Thomas Chinn sits atop a horse in France during World War I c. 1917. Chinn's house still stands on the south side of White Oak Road across from the White Oak Museum. (Janet Chinn LeCouteur.)

Church picnics have sure changed. People don't dress like these eight ladies, the gentleman, and three children did for the Andrew's Chapel's picnic at Brooke in 1908. (Eileen Shelton Greene.)

Ada Dent (left) and Mary Magdeline Dent stand in front of the Jones homeplace. Mary married Davis "David" Monroe Jones. Their son, "Dishpan Dent," played music with the Lazy K Cowboys. The group performed all around the county and state, and their music was broadcast on the radio. (The Almon Jones family.)

Thomas Silvester DeShazo was a deputy sheriff of Stafford County. In this photograph, he holds his two workhorses, Mable and Beauty. The family tells the story that DeShazo was called to investigate a double-murder, and he had to ride on horseback to the crime scene through snow that was shoulder high to his horse. (Lou Y. Silver.)

Annie DeShields posed for Gari Melchers's *A Native of Virginia* in 1925, and for six other works. Melchers had seen DeShields while passing a farm in the Garrisonville area. Melchers asked DeShields to sit for him. When she arrived for the sitting, she was wearing her best Sunday clothes instead of her work clothes that Melchers wanted. She agreed to change but ironed her work clothes for the sitting, much to Melchers's dismay. (Belmont, the Gari Melchers Estate and Memorial Gallery, University of Mary Washington, Fredericksburg.)

The home of Henry Washington Edwards, which the family called New Boscobel, was located off Brooke Road. The eight people in this photograph are, from left to right, Serena Edwards, Minnie Edwards, Price Greenlaw Edwards, Kate Edwards, Lee Fleming (child), Henry Washington Edwards Jr., French Fleming (far back), and Henry Washington Edwards Sr. (Lou Y. Silver.)

Buck Embrey, a bachelor, sits (at left) with his two unmarried sisters, Harriet (center) and Sue (right), on the porch at the Embrey family farm. (Joyce W. Sterne.)

These students posed in front of the Falmouth First Form School around 1890. St. Clair Brooks sits at far left with a dog. Although several locals believe the location of the school was at the corner of the Belmont Estate, others disagree. (Marian B. Robinson.)

The Falmouth School class of 1912 gathered to pose for this photograph. The teacher's name is believed to be Leona Cloe. Hula Payne sits fifth from the right on the front row and Julia Payne sits to the right of Hula. The school was located near a present-day law office in Falmouth on Butler Road. (Charles W. "Togie" Payne.)

The 1939 Falmouth High School May Day celebration was a big production. Wayne Skinner (near center) was six years old when he was picked to be the crown bearer for the yearly event. (Wayne Skinner.)

Falmouth High School was constructed in 1930–1931. This photograph shows the Falmouth High School junior and senior classes of 1931–1932. (Shirley Heim.)

These biology students from Falmouth High School took a field trip to Belmont in 1940. Miss Yeager's students are, from left to right, (first row) George Blackburn and John Clift; (second row) Clifton Burton, Francis Brown, Hazel Hanks Tucci, John Benton, William Snellings, Joseph Beagle, Adrian Hamn, and Silas Hewitt; (third row) Thelma Boutchyard, Marie Verberg Blackburn, Alma Burton Johnson, Edna Smith Leach, Marie Truslow, Mildred Hemp Davis, Leathie Mae Jett Hudson, Caroline Brooks Hoffman, and Gloria P. Sullivan; (fourth row) Harry Brown, Mabel Hanks Sullivan, Frances Snellings Balderson, Mary Bland, Vera Barber Smith, Alene Patton Graves, and Sadie Coakley Cooper. (Shirley Heim.)

Eleanor Watson Fleming posed for this c. 1934 photograph near the home of Walter and Mabel Watson in the Brooke area of Stafford. (Eileen Shelton Greene.)

Aunt Chaney Grant was a mammy in the Wallace family. The date of the photograph is not known. (Daniel M. Chichester.)

From left to right at the top of this photograph are Frank "Pap" Green, playing left-handed fiddle; Charlie King on guitar; his son, Mike King, playing bass; and Alvin Sharky "Frog" Newton, father of Mark Newton. They appeared on *Ted Mack Amateur Hour* c. 1951–1952. Although they won, Frank "Pap" Green did not want to make a return appearance because he did not like traveling so far from home. (Rev. E. T. "Tick" Bourne.)

William J. Howell, born in Washington, D.C., in 1943, has lived in Stafford for more than 20 years. He earned a B.S. in business administration at the University of Richmond and law degree from the University of Virginia. A Republican first elected to the house in 1988, representing part of Stafford County and Fredericksburg, he served as chairman of the Courts of Justice Committee and member of the Finance, Transportation, and Chesapeake and Its Tributaries Committees. He is currently the Speaker of the Virginia House of Delegates. Gov. Mark Warner described Howell as "a fair and honest individual, as well as a gentleman." He is married to Cessie, and they have two grown sons and five grandchildren. (The Honorable and Mrs. William J. Howell.)

Will Humphries (far left), helps William Gordon Shelton Sr. (middle left), Harvey Fleming (middle right) and Elliott Shelton (far right) cut up logs for firewood in the late 1940s. The portable sawmill would be moved to each neighbor's home to cut wood. Chores like cutting wood and butchering hogs were opportunities for neighbors to help each other and socialize. The women would prepare the food for the families who gathered while the men did the work. (Eileen Shelton Greene.)

Lessie, Mamie, Nettie, Laura, and Luona Jett enjoy splashing in the Rappahannock River on Falmouth Beach at Frank Hill's Fishing Shore. The old Falmouth Bridge can be seen in the background. (Dorothy Simpson.)

Mamie and Nettie Jett ride Harper on Falmouth Beach at Frank Hill's Fishing Shore in this early-1900s photograph. (Dorothy Simpson.)

Cruise Jones, the bartender of a Falmouth saloon, stands on the left in the doorway. The names of the other men in this c. 1910 photograph are not known. (Marian B. Robinson.)

William LeCouteur Sr. established LeCouteur's Nursery near the Ferry Farm area of Stafford. He was the son of an English seaman who became a farmer, a carpenter, and even ran an egg hatchery. LeCouteur retired after 36 years of operating his nursery on Kings Highway, turning the nursery business over to his children. He then began building lawn furniture and other novelty wood items. LeCouteur was 90 years old in this photograph. LeCouteur's Nursery was sold in the 1990s. (Janet Chinn LeCouteur.)

R. C. L. Moncure, a chief justice of the Supreme Court of Virginia, bought Glencairne Farm in Stafford County in 1825. Moncure put an addition on the back of the house in 1839, and by his death in 1882, he had increased the size of the farm from its initial 200 acres to 1,000 acres. His daughter, Agnes, inherited the farm after his death. (Daniel M. Chichester.)

Gari Melchers and his wife, Corinne, posed for this photograph while standing on the rear porch of the house at their 18th-century estate, Belmont, located in Falmouth. Gari Melchers (1860–1932) was an internationally famous American Impressionist painter. Primarily a portrait artist, Gari's most famous portrait was of then-president Theodore Roosevelt, which is owned by the Freer Gallery in Washington, D.C. (Belmont, the Gari Melchers Estate and Memorial Gallery, University of Mary Washington, Fredericksburg.)

Gari Melchers used a number of people from the area as models for a series of three murals he executed for the Detroit Public Library in the 1920s. *Conspiracy of Pontiac* is the mural shown. Melchers employed his wife's cousin, McGill Mackall, standing next to Melchers's mural in the old stone bakery building in Falmouth. Mackall did research sketches, helped prepare canvases, and probably painted portions of the final work. Melchers used the building as a temporary studio until he had a studio constructed at his Belmont Estate just up the road. (Belmont, the Gari Melchers Estate and Memorial Gallery, University of Mary Washington, Fredericksburg.)

This postcard shows the 1896 self-portrait by Gari Melchers at age 36. The same year, Melchers painted *The Sermon*, which was the first work for which he gained recognition as an artist. The Smithsonian American Art Museum in Washington, D.C., owns *The Sermon*, c. 1886, *The Bride*, c. 1907, *Mother and Child*, c. 1920, and *Arranging the Tulips*, before 1928. Melchers painted two murals, *War* and *Peace*, which adorn the walls of the Library of Congress in Washington, D.C. The murals echo themes of paintings Melchers did for the World's Columbian Exposition at Chicago in 1893. The study for the mural *War* hangs in Melchers's former art studio at Belmont in Falmouth. A large part of his wealth was earned painting portraits. During his time at Belmont, he recorded many beautiful landscapes around Stafford as well as many of the local people and historic sites around Falmouth. (Belmont, the Gari Melchers Estate and Memorial Gallery, University of Mary Washington, Fredericksburg.)

Corinne Melchers holds her macaw, Polly, while her dog stands watch. Corinne deeded Belmont, its furnishings, decorative arts, papers, and the remainder of her husband's art to the Commonwealth of Virginia in 1942. She continued to live at Belmont until her death in April 1955. (Belmont, the Gari Melchers Estate and Memorial Gallery, University of Mary Washington, Fredericksburg.)

Virginia Burzio Myers (far right) joins the "weenie roast" at her family's Mount Ringold Farm on White Oak Road. Her children, Bob (far left) and Barbara (standing), share the fun with their friends David (second from left), Peggy, and Paul Scott. Virginia Myers donated an acre of her land on Route 218 to establish the White Oak Volunteer Rescue Squad. Bob and Barbara gave another acre after their mother's death in the 1990s. Mount Ringold Farm is now a subdivision. (Margaret T. Scott.)

Conroy "Frog" Newton, who lived near Belle Plains, joined the navy and served his country only to die later when a tractor rolled on him. (White Oak Civil War Museum and Stafford Research Center.)

George Henry Newton, Archie Newton's father, paints one of the boats used as rentals to bass fishermen for hauling seine and to ferry people to larger boats moored in deeper waters. (White Oak Civil War Museum and Stafford Research Center.)

William Tice Callahan (left) and George Henry Newton steam crabs in a metal drum in this 1930s photograph. At that time, only cooked crabs could be sold to the public. Green crabs could not be sold. When selling green crabs was allowed, Newton would put brush between layers of crabs so they would have enough oxygen during transport. Newton sold the crabs for 12¢ a dozen. The Newtons continue crabbing today. (White Oak Civil War Museum and Stafford Research Center.)

51

Wayne Newton, a popular singer since the 1960s, posed for a photograph with Evelyn Bullock in this 1960s photograph. Newton, who is related to the Newtons in the White Oak area of Stafford County, won a contest singing at the Fredericksburg Kiwanis Club Annual Talent Show in the early 1950s. He went on to become a famous singer with many hit songs including "Danke Schoen." Newton and Elvis Presley share the fact that neither was invited to appear on the *Ted Mack Amateur Hour* after auditioning for the show. Newton appeared with Jackie Gleason and Lucille Ball. His career is still going strong in Las Vegas. (White Oak Civil War Museum and Stafford Research Center.)

Susie E. Noonan was the daughter of Alice Sullivan and a Union soldier named Noonan. The family story about how Susie's parents met is an unusual one that began when Union soldiers camped around present-day Newton and White Oak Roads. Noonan stole a pie that was cooling in Alice Sullivan's window. After realizing her pie had disappeared, Sullivan marched over to the officer in charge of the Union troops and demanded the return of her pie. After the war was over, Noonan returned to Stafford to find the maker of the pie he had pilfered and married her. (Sandra Chinn Hammond Janet Chinn LeCouteur.)

George E. "Slickpot" Payne, a Falmouth native, married Julia E. Payne. He left his hometown of Falmouth when he became a private in Company K, 116th Army Infantry. He came home only a couple years later to find his hometown had gone through a dramatic change. He fished all his life and worked with his father as a stonemason, as a contractor, and 24 years at the Sylvania plant before retiring. (The *Free Lance-Star* newspaper, Fredericksburg; Charles W. Payne Jr.)

Julia E. Payne was 20 years old when she posed with her firstborn for this painting by Gari Melchers. The baby she cradled in her arms, named Ivan, was the first of her 10 children with her husband, George E. "Slickpot" Payne. She posed at least once more for Melchers. A Stafford native, she lived in Falmouth after her marriage and until her death at age 82 in 1977. She was soft-spoken and friendly and liked to entertain visitors. Her son Ivan died in 2004. (Joann Payne and the Payne family.)

Nelson Payne (left) and St. Clair Brooks, obvious friends, posed for this c. 1908 photograph. (Marian B. Robinson.)

Quilting bees are rare these days. Pictured here in May 1963 are, from left to right, Becky Worrell, Louise Payne, Marge Dews, Mabel Watson, and Edith Fleming, all of whom are working hard to complete this quilt. Eileen Shelton Greene is lucky to own the quilt that is pictured. (Eileen Shelton Greene.)

Esau Rose came home to Stafford after his military service to marry the teacher of the Stage Road School, Ethel Leake. (Lou Y. Silver.)

James Rowser was the subject in this portrait by Gari Melchers, titled *Uncle Jim* and dated 1918. (Belmont, the Gari Melchers Estate and Memorial Gallery, University of Mary Washington, Fredericksburg.)

55

Catherine Shelton and Raymond Crismond stop for a Coke at Gordon Shelton's gas station located across from Stafford Courthouse on U.S. Route 1 and State Route 630 on July 4, 1955. (Eileen Shelton Greene.)

Elliott Shelton worked on a streetcar in Washington, D.C., before working for the Richmond, Fredericksburg & Potomac Railroad (RF&P) in Fredericksburg. His son, William Gordon Shelton Sr., drove his father to catch the train to work because Elliott didn't drive. Amazingly, on many occasions when Elliott rode the train home, he would just jump off the moving train as it passed his home. (Eileen Shelton Greene.)

William Gordon Shelton Sr. had many professions in his lifetime. He ran a gas station, built houses, and farmed. Of these, his favorite profession was farming. In this *c.* 1948 photograph, Shelton delivers building materials for his own home using his team of horses, Betsy and Maude. (Eileen Shelton Greene.)

Nellie Watson Shelton stands near the old Shelton home in this *c.* 1930 photograph. The oldest part of the house in the back was made of logs. It had one room upstairs and one down. The home is still located in the Brooke area. (Eileen Shelton Greene.)

57

Nellie Shelton (with hands on hips) is the only identified person in this 1941 photograph of the people who gathered together at Aqua-Po Beach for the Andrews Methodist Episcopal Church picnic. Aqua-Po Beach is where Aquia Landing was located. (Eileen Shelton Greene.)

Pearl Watson Shelton, daughter of Walter and Mabel Watson and wife of William Gordon Shelton Sr., hangs the wash on the clothesline in this c. 1940 photograph. The washhouse is behind her. Doing the laundry was an all-day job before modern washing machines and dryers were invented. (Eileen Shelton Greene.)

Nellie and Pearl Watson Shelton wash and wring clothes in the washhouse in the 1950s. If you mention an old wringer-type washing machine, more often than not, you will hear a story about someone having their arm caught in the rollers that squeezed the excess water from the washed clothes. Those roller mechanisms could have used a modern-day warning label. (Eileen Shelton Greene.)

Sam Shelton ran a country store in the Brooke area of Stafford. Business and store signs used to be made in the shape of the service or product offered because so many people could not read. Maybe the bananas hanging from the roof near the entrance to Shelton's store told people what he had for sale or maybe he was just showing off the exotic produce he carried. (Eileen Shelton Greene.)

William Gordon Shelton Sr. posed next to the Chevy the family owned c. 1926. Although Shelton was only 16 years old, he was the family driver. He gave up trying to teach his mother to drive after she became frightened when another car passed her on the road. She screamed and threw her hands in the air to drive no more. (Eileen Shelton Greene.)

William "Billy" Gordon Shelton Jr. steadies Betsy and Maude after firewood was brought to the home of Elliott Shelton in this c. 1944 photograph. (Eileen Shelton Greene.)

Anne Skinner became a Red Cross nurse's aide and volunteered at Mary Washington Hospital in 1944. During World War II, doctors and nurses were in short supply. The aides helped prevent the closing of floors, wards, or rooms as many other hospitals had done. Anne was one of nine children born to George and Elizabeth Skinner. (Wayne Skinner.)

James "Jimmie" (left) and Kenneth "Kennie" Skinner were happy about getting a ride on their family's horse, Spark Plug, on the Skinner farm on Cool Springs Road about 1946. (Wayne Skinner.)

The Skinner boys (from left to right), John (12), Wayne (9), Kenneth (7), and James (5), stand proudly in front of the log cabin they built in the early 1940s from logs cleared when the railroad to Dahlgren was put through. (Wayne Skinner.)

Shown from left to right, Anne, Lois, Hazel, and Nellie Skinner play in the Coston family's front yard on Cool Springs Road. Mrs. Coston took the photograph in the late 1930s or early 1940s. "All Heartbreakers" was written on the back of the photograph. (Wayne Skinner.)

This c. 1900s photograph is believed to be the one-room school located where Stafford County Landfill is today. Shown from left to right are (first row) Nettie Beagle, Mary F. Watson, Fannie ?, Leslie and Minnie Taylor, Hattie Dickinson, Bessie ? (teacher), Cora Watson, Ida Smith, and Maude Payne; (second row) Dan Beagle, Todd Ferneyhough, Jim Frazier, George Taylor, John Ferneyhough, Robert Boutchyard, George Watson, Edward Payne, and Bernard Patton; (third row) Estella Payne, Florence Truslow, Birdie Payne, Grace Watson, Clara Smith, Kate Street, ? Street, Lizzie Street, Nellie Watson, and Bertha Patton. (Eileen Shelton Greene.)

This is another school class believed to be in the Brooke area of Stafford County. The names of the teacher and students are not known. (Eileen Shelton Greene.)

63

The 1940 Stafford High School staff included, from left to right, (seated) Dorothy Blackburn and Pearl Scholer; (standing) Lucille Lambert, Agnes Anderson, Cecil Barlow, Dick Knoxville, Wesley Freeman, Ruby Keller, Bobby Gordon, and Norvin Decker. A typewriter and mimeograph machine are displayed on the table. (Shirley Heim.)

The 1940 Stafford High School officers, from left to right, are (seated) Mr. Snellings, Mrs. Betsy Sacrey, and Mr. Beable; (standing) Mrs. Neill and Miss Clay. (Shirley Heim.)

The teachers at Stafford High School in 1940 were, from left to right, (seated) Miss Sterns, fourth grade; Mrs. Beable; Mrs. Crismond, first grade; and Miss Wallace, third grade; (standing) Mrs. Souder, seventh grade; Mrs. Mountjoy, second grade; Miss Robinson; Miss Cloe, sixth grade; and Mrs. Freeman, seventh grade. (Shirley Heim.)

The Stafford High School women's basketball team won 6 games out of 10 games played in 1940. The players were, from left to right, (kneeling) Kitty Moncure, Connie Thomas, and Ruby Keller; (standing) Bertha Crismond, Pearl Schooler, Mrs. Sacrey, Cordell Vaughn, Margaret Cole, Emma Heflin, Dorothy Blackburn, Ida Schooler, and Lucille Lambert. (Shirley Heim.)

The Stafford High School men's basketball team won 9 games out of 13 games played in 1940. The players were, from left to right, Dick Knoxville, Cecil Barlow, Stanley Bryant, Dick Dent, Turner Blackburn, Kitty Moncure, Wesley Freeman, James Skinner, Jack Perry. Kneeling is Coach Beable. (Shirley Heim.)

Pictured is the Stafford High School freshmen class of 1940. Only last names are known. From left to right are (first row) Dickerson, Huffman, Kee, Barber, Sneed, Conway, Cloe, Frazier, Boswell and Wandrick; (second row) Musselman, Bryant, Bryant, Barlow, Decatur, Davis, Patterson, Gallahan, Humphries, Pearson, Snellings, and Armstrong; (third row) Dickerson, Barlow, Moncure, Tolson, Dent, Woodard, Trembley, Payne, and Reid; (fourth row) Samsky, Gibson, Byram, Flack, Knight, Raines, Massey, Vayda, and Segar. (Shirley Heim.)

Pictured is the Stafford High School sophomore class of 1940. Only last names are known. From left to right are (first row) Dent, M. Dent, Musselman, Embrey, Heflin, Dickerson, Knight, Hill, Vayda, Heflin, and Beable; (second row) Flatford, Skinner, Ball, Barber, Tyson, Kee, Vaughan, Heflin, Grigsby, and Dent; (third row) McMichael, Randall, Bridwell, Cloe, Barlow, Byan, Schooler, and Heflin; (fourth row) Moncure, Samsky, Huffmen, Cooper, Winkler, Jett, Segar, Decatur, and Tyson. (Shirley Heim.)

Pictured is the Stafford High School junior class of 1940. Only last names are known. From left to right are (first row) Snellings, Meyers, Thomas, Grey, Payne, Guy, and Lancaster; (second row) Mrs. Neill, Fritter, Burton, Woodard, Flack, Nelson, and DeShields; (third row) Perry, Moncure, Blackburn, Cole, Shelton, and Mountjoy. (Shirley Heim.)

Stafford High School's Future Farmers of America in 1940 are, from left to right, (first row) ? Woodard, ? Dickerson, ? Wandrick, ? Boswell, and ? Jett; (second row) ? Vayda, ? Dickerson, ? Massie, ? Bridwell, ? Dent, and ? Segar; (third row) S. K. Young, Billy Cloe, ? Moncure, Turner Blackburn, Howard Cooper, ? Raines, and ? Flack. (Shirley Heim.)

May Day celebrations are a thing of the past. This 1947 photograph shows how important the event was to the students at Stafford High School. The name of the May Queen, surrounded by her court, is not known. (Shirley Heim.)

68

Maypole dances are almost unheard of by the current generation. But May Day celebrations were a big deal in the 1940s. This 1947 maypole dance was held at Stafford High School. (Shirley Heim.)

This c. 1915 photograph shows the teacher and students of the Stage Road School, located on Belle Plains Road. Their names include Jake Newton, Meral Green, Elsie C. Fines, Suck Green, Roxie Sullivan, Beulah Lynn Cox (teacher), Bob DeShazo, Roy Newton, Pearl DeShazo, Wesley Newton, Enis Fines, Carl Newton, Irwin Allen, and Job Newton. (Rev. E. T. "Tick" Bourne and White Oak Civil War Museum and Research Center.)

Pictured in these family portraits are Charles M. and Catherine Davis Sterne, the ancestors of Charles Montgomery Sterne, who was a hospital steward with the 9th Virginia Cavalry. Catherine was from Bristol, England. (Joyce W. Sterne.)

John E. Sterne, age 14-and-a-half-months months, gets a ride with his father, Thompson W. Sterne, on his uncle Charlie Sterne's Ford tractor in this 1959 photograph. (Joyce W. Sterne.)

Joyce Weimer Sterne was in her 20s when this photograph was taken. She married Thompson W. Sterne from the Concord area of Stafford. They reared two sons, John and Charles. She worked for Chichester and Dickerson Insurance for eight years then became a docent at Belmont, where she has worked for 30 years. (Joyce W. Sterne.)

From left to right, Robert Cleveland Sterne, Virginia "Jennie" Sterne Moore, Charles Montgomery Sterne, and John Edward Sterne pose for this photograph in the Roseville area of Stafford. (Joyce W. Sterne.)

The Sterne family enjoyed a visit from their friends, the Kelly family from Alexandria, in this photograph. Shown from left to right are (front row) the Sterne children—William, Marion, Margaret, and Tom (behind Margaret)—and the Kelly children, names unknown; (back row) Ethel and Ed Sterne, Mrs. Kelly, and Mr. Kelly. William "Bill" Sterne owned and operated a country grocery store and gas station with his wife, Anna, in the Concord area of Stafford County at the intersection of Routes 616 and 627. (Joyce W. Sterne.)

George Storck sits on the porch of his store located on Marsh Road, what is now Warrenton Road or Marsh Road (U.S. Route 17), in Stafford County near the border with Fauquier County. (Shirley Heim.)

Mr. and Mrs. Ward (left) and Mr. and Mrs. James Thomas Chinn of Stafford show off the fish they caught at Belvedere Beach in King George County located near the mouth of Potomac Creek. (Janet Chinn LeCouteur.)

Walter Lee Watson (at left), his grandson Pete, Mabel Watson, Evelyn ?, and Louise Watson Payne (later Potter Payne's wife) gather for a fish fry at Potter Payne's on Aquia Creek in 1944. (Eileen Shelton Greene.)

Mabel Ashton Jones Watson took a moment to check her eyeglasses in the doorway of her home in the Brooke area of Stafford. Note the stone block used as a step to enter the house. She was 59 years old in this 1944 photograph. (Eileen Shelton Greene.)

Walter Lee and Mabel Jones Watson posed for this photograph in 1934. Walter was 59 years old and his wife was 49. Walter built and ran Watson's General Store at Brooke. He bought and sold real estate, farmed, raised hogs, and cut grass for others with his tractor and sickle bar. Having a wooden leg didn't slow him down. Paul Scott remembers the Watsons fondly during visits made when his family stopped in on their way to their cottage on Aquia Creek. He recalls the smell of the Mrs. Watson's wood stove in the kitchen wafting throughout the house. Scott's parents would regularly buy home-churned butter and buttermilk from Mrs. Watson. (Eileen Shelton Greene.)

Willard L. Watson, son of Walter and Mabel Watson, gave his life for his country. Written on the back of this photograph is "hair-dark brown, eyes-blue, clothing-kaki, Marine, W. L. Watson, killed on Iwo Jima, March 6, 1945. This is my brother." (He was Pearl Watson Shelton's brother.) The battle for Iwo Jima was one of the most costly battles of the Pacific Campaign of World War II. This photograph was taken in September 1944. (Eileen Shelton Greene.)

Most of the members of the White Oak Baseball Team were named Christy. John Ashton Christy is pitcher, Milton Christy is at bat, William Medford Christy is catcher, Chester Miles Christy is the umpire, and Joseph Samuel Christy, Milton's grandfather, sits and watches the practice session in this c. 1940 photograph. Milton Christy saved enough sticks from the Eskimo Pie ice creams eaten at the dances where his father played fiddle to send away for the baseball uniform he wears. The land where the team practiced in this photograph was taken by the State for State Route 17, Warrenton Road. Many of the buildings on the "Christy Place" were moved before construction began to the north side of the new highway. (Milton S. Christy.)

This "Womanless Wedding" was held as a fund-raising event. Perry Thompson, the groom, worked at the *Free Lance-Star* newspaper, and T. Benton Gayle, the bride, was superintendent of schools in Stafford and King George Counties. Mrs. Thompson, shown in the lower left corner, worked in the office at James Monroe High School in Fredericksburg. James Thomas Chinn Sr. is on the left of the groom. Joe Chinn is on the back row, second from left. (Janet Chinn LeCouteur.)

Four generations of Stafford women are shown in this photograph. Rebecca Young (Guy), left, is on the lap of her grandmother, Annie DeShazo Edwards, and Rebecca's sister, Lou Young (Silver), is on the lap of her great-grandmother, Mary Jane Roberson. Pearl Edwards Young, mother of Becky and Lou, is standing in the back. (Lou Y. Silver.)

Six

Places

The early history of the Barnes House, c. 1780, is not known. Joseph B. Ficklen, a former owner of Belmont, bought the house in 1850 and later sold it to Harrison Barnes. After the death of Barnes and his sisters, Barnes's former slaves, Annie Duncan and Daniel Lucas, were given a life estate in the property. The Barnes House is located at the corner of Washington Street and Ingleside Drive in Falmouth. Today, the Barnes House is dilapidated and is supported by wooden beams. (Belmont, the Gari Melchers Estate and Memorial Gallery, University of Mary Washington, Fredericksburg.)

These aerial photographs show Belmont and its surroundings, including much of the Falmouth area and the rural countryside, looking north and west, before the construction of Interstate 95. The following 24 photographs give a "virtual" tour of Belmont, the estate of Gari and Corinne Melchers. (Belmont, the Gari Melchers Estate and Memorial Gallery, University of Mary Washington, Fredericksburg.)

Belmont, c. 1790, waits for visitors beyond theses gates. After passing through, the first building you see is the garage, which was remodeled to house the Stroh Visitor Center and Museum Shop. The estate, which is a Virginia Historic Landmark and a National Historic Landmark, includes the house, summerhouse, studio, garage, museum shop, and other outbuildings on approximately 27 acres. (Belmont, the Gari Melchers Estate and Memorial Gallery, University of Mary Washington, Fredericksburg.)

Boxwoods line the path that leads to the beautiful curved double staircase at the formal entrance of Belmont's house. The stairs have impressive wrought-iron handrails that run from the ground to the porch above. Many visitors have come to enjoy the beauty of Belmont over the generations. Vice Pres. Calvin Coolidge and former prime minister David Lloyd George were guests at Belmont in the early 1920s. (Belmont, the Gari Melchers Estate and Memorial Gallery, University of Mary Washington, Fredericksburg.)

Belmont has had many owners through the centuries. Their names include Richards, Horner, Voss, Knox, Ficklen, and Melchers. The house has had many additions through the years. The last private owners, Gari and Corinne Melchers, added the sun parlor (and two bathrooms) on the southern end of the house, which was the last major addition, bringing the total number of rooms to 16. (Belmont, the Gari Melchers Estate and Memorial Gallery, University of Mary Washington, Fredericksburg.)

This photograph of the rear elevation was taken after 1921 and shows the screened second-story summer porch and the springhouse in the foreground. The rear entrance of the house at Belmont is the one most used. (Belmont, the Gari Melchers Estate and Memorial Gallery, University of Mary Washington, Fredericksburg.)

This photograph and the next seven were taken about 1927. They show the interior of Belmont with the extensive European and American antique furniture, art, and decorative arts collections of the Melchers. The hall at Belmont connects the front and back entrances. The stairs and stair landing were altered probably around 1850. Their original location and configuration are not known. (Library of Congress.)

The parlor at Belmont was originally two rooms. The Ficklens removed sliding panels dividing the two parlors. The portrait hanging over the mantel above is of Sir Henry Dudley and his wife by Gainsborough Dupont. Dudley was the nephew of and apprentice to Sir Thomas Gainsborough, who also painted *Blue Boy*. The oak corner cupboard was made in Holland and dates to about 1720. An English mahogany Chippendale mirror from the late 18th century hangs over the mantel below. The firebacks are French and date to the 19th century. (Library of Congress.)

The Melchers added a sun parlor off the south elevation of the house. An abundance of Corinne Melchers's plants thrive in the sun parlor, visible in the image at left. Though Corinne had studied art before marrying Gari, she spent more of her time gardening after moving to Belmont, where she was a member of the Rappahannock Valley Garden Club. (Top: Library of Congress; left: Belmont, the Gari Melchers Estate and Memorial Gallery, University of Mary Washington, Fredericksburg.)

A Dutch wall cupboard, which dates to about 1790, hangs to the right of the doorway leading into the formal dining room from the hall at Belmont in the photograph at right. The chest beneath the cupboard is English is made of oak in the Jacobean style and dates to about 1680. A *c.* 1870 Dutch klapbuffet sits to the right of the dining room fireplace in the bottom photograph. The 12-by-7-foot painting *Market Scene*, by the workshop of Frans Snyders (Flemish, 1579–1657), hangs on the left wall. (Library of Congress.)

The split-level granite and sandstone studio was built on the Belmont grounds in 1924–1925. George Walker Payne, a local stonemason, had a hand in its construction. Payne used horses to pull some of the stone used out of the Rappahannock River and loaded them onto wagons to carry them to the job site. The memorial plaque on the exterior wall on the right of the entrance marks the last resting place of Gari and Corinne Melchers, who died at their beloved country estate in 1932 and 1955 respectively. (Belmont, the Gari Melchers Estate and Memorial Gallery, University of Mary Washington, Fredericksburg.)

These two photographs show the interior of the stone studio building at Belmont. The paintings beginning at left in the top photograph are *Arcadia*, *Nude at a Tapestry Chair*, *Portrait of Mrs. Gari Melchers* (on the easel; ownership unknown), *The Caress*, *Brabant Bride*, and *Self Portrait as a Young Man*, all by Gari Melchers. The two small paintings in the chairs on either side of *Brabant Bride* are florals, also by Melchers. The larger paintings in the bottom photograph are *Portrait of Gari Melchers* (on the wall, center), painted about 1903 by American painter James J. Shannon, and *Anna and Her Baby*, by Gari Melchers, which rests on the easel. (Belmont, the Gari Melchers Estate and Memorial Gallery, University of Mary Washington, Fredericksburg.)

The top photograph shows the rear or west façade of the stone studio at Belmont. The studio was renovated in 2000, and a large, two-story pavilion was added in 2005 to the southwest corner. The bottom photograph shows the view of the Rappahannock River from the grounds near the studio, looking southwest. (Belmont, the Gari Melchers Estate and Memorial Gallery, University of Mary Washington, Fredericksburg.)

The last addition to the estate complex was a stone summerhouse Gari and Corinne Melchers had built to resemble one they had seen in Salzburg, Austria. The summerhouse, built in 1932 and located at the south end of the lawn, overlooks the Rappahannock River and the beautiful flowering plants and trees that have been reestablished according to Corinne's original design, which she called the Grove. Today, Belmont has the largest repository of Melchers's work in the world. (Belmont, the Gari Melchers Estate and Memorial Gallery, University of Mary Washington, Fredericksburg.)

The building shown in the lower pasture on the east side of Belmont may have been used as a schoolhouse for the Ficklen children. These 1966 photographs were taken as the structure was being torn down. (Belmont, the Gari Melchers Estate and Memorial Gallery, University of Mary Washington, Fredericksburg.)

Berry's Grocery offered shade for people gathered to watch the traffic and share the day's news and gossip. The Old Dutch Cleanser sign on the corner of the building is a hint of what is offered inside. The building housed several versions of Berry's Grocery. In the early 1940s, it was Monroe and Berry Grocery. (Belmont, the Gari Melchers Estate and Memorial Gallery, University of Mary Washington, Fredericksburg.)

The original Concord School was built of logs. The Concord School building located on Route 627 was built through the Works Progress Administration. This photograph shows the front of Concord School. (Joyce W. Sterne.)

The old Cotton Warehouse, built around 1780, is located at 201 Cambridge Street. It was a two-story frame building. The wooden roof was replaced with tin. The original dependencies, which included a meat house, stable, kitchen, and milk house, have not survived. The building has had many uses. During the 18th century, Basil Gordon probably used it as a cotton warehouse. The warehouse became the residence of the Duff Green family after the Civil War. It now houses a real estate company. (Photograph by author.)

The Edwards homestead is shown in this late-1800s photograph. The family called it "New Boscobel." It was located just off Brooke Road. The people in the photograph are identified in an enlargement in chapter six. (Lou Y. Silver.)

The Falmouth House, chartered in 1720, is at left in this c. 1918 photograph. The two mules have just pulled the wagon across the old Falmouth Bridge. The Falmouth House faced Cambridge Street, the main thoroughfare. Falmouth House was later razed. (Belmont, the Gari Melchers Estate and Memorial Gallery, University of Mary Washington, Fredericksburg.)

The building at left was probably a store that sold general merchandise. A Star Soap sign is on the right front of the building. In the early 1900s, there were five grocery stores and five barrooms in Falmouth, according to Slickpot Payne. (Belmont, the Gari Melchers Estate and Memorial Gallery, University of Mary Washington, Fredericksburg.)

The cottage shown in this early photograph has the very steeply pitched roof that was typical of old homes in the Falmouth area. This cottage was located on Lafayette Boulevard in Fredericksburg. (Belmont, the Gari Melchers Estate and Memorial Gallery, University of Mary Washington, Fredericksburg.)

This c. 1850 lithograph shows the Falmouth area and the wooden bridge over the Rappahannock River. The Moncure Conway House, Green's Pickle Factory, a mill, and Allison's Trading Post can also be seen. (Marian Robinson.)

This aerial photograph of Glencairne shows the rural landscape along Route 1 in Stafford as well as the home of Richard Henry Lee Chichester Jr. in the distance. Glencairne is the ancestral home of the Moncure/Chichester family. The Carters, Seddons, Finnalls, Langfits, and Moncures owned Glencairne prior to the Chichester ownership. (Daniel M. Chichester.)

Glencairne, c. 1804, has been in the Chichester family for four generations and has been the home of two Supreme Court justices and three members of the General Assembly of Virginia. Richard Cassius Lee Moncure (later chief justice of the Virginia Supreme Court) purchased Glencairne, which contained 200 acres, in 1825. By his death in 1882, the farm contained 1,000 acres. Agnes Robinson Moncure Chichester, wife of Judge Daniel McCarty Chichester of Fairfax, inherited Glencairne upon her father's death. Their son, Judge Richard Henry Lee Chichester, inherited Glencairne in 1919. Today, Daniel McCarty Chichester owns Glencairne. (Daniel M. Chichester.)

Glencairne's original kitchen was a detached log structure. The identities of the people in the photograph are not known. The one-story, lean-to kitchen built on the north façade of the house was a risk given the fire hazard. A second story was added to the kitchen later. (Daniel M. Chichester.)

The old barn at Glencairne (above) burned in 1984. The new dairy barn was constructed at Glencairne around 1920, with part of the money made from selling Judge Chichester's prize bull, King of Chillmark. (Daniel M. Chichester.)

This photograph shows the old milk house at Glencairne. The old barn seen in the distance burned, and a new one was built. (Daniel M. Chichester.)

Glencairne was primarily a dairy farm, but feed crops were grown using man and mule power nearly a century ago. (Daniel M. Chichester.)

The Gordon House, c. 1830s, (the brick home in middle) was the home of Falmouth businessman Basil Gordon, one of America's first millionaires. He dealt in tobacco, cotton, and general merchandise and was involved in shipping. The Gordon House still stands on what was once 303 King Street and is now River Road. Moncure Conway's family purchased the house (far right) in 1838. The home dates to at least 1807. A Stafford native born in 1832, Conway was an abolitionist. Even after being ostracized by his family and community, he continued to believe in equality and free public education for everyone. Though it was illegal, he taught slaves to read in his home. A 19th-century author, lecturer, and clergyman, he lived in America until 1865 then lived abroad. (Belmont, the Gari Melchers Estate and Memorial Gallery, University of Mary Washington, Fredericksburg.)

Charles D. Green's residence in the Brooke area of Stafford is shown in this c. 1909 photograph. Charles Green's daughter-in-law, Eva Green, still lives in the house that he built. (Eileen Shelton Greene.)

C. D. Green's Store and Log Yard are shown in this c. 1900 photograph. Oxen were used to pull the logs. The store was located in the Brooke area. The Green's Store site may have been where Grove's Store was located. In the 1950s, Frank A. Turner ran a country store there. His sign read, "F. A. Turner, Meats." (Eileen Shelton Greene.)

Hartwood Manor is located on Route 612, in the Hartwood area of western Stafford. It was built on a part of the original Hartwood plantation owned by Arthur Moroson around the mid-1700s. Moroson prospered in the mercantile business in Falmouth after moving from Scotland. The plantation contained 3,677 acres when it was surveyed in 1870. Peter Nuccio, a more recent owner, took this photograph in the 1970s. (Peter A. Nuccio.)

Davis "David" Monroe Jones purchased the 115-acre farm that became the Jones Farm c. 1887. The farm is near Brooke. This aerial photograph was taken in 1970. The house seen in the foreground was built using cinderblocks, as were many of the homes in the area. The old Jones homeplace is seen at the top of the photograph. (The Almon Jones family.)

Laurel Hill stood until the Interstate 95 and Warrenton Road (Route 17) cloverleaf was built in 1966. John P. Simpson owned the family home before it was razed. (Dorothy Simpson.)

William Norman LeCouteur Sr. started the LeCouteur's Nursery business in 1919 on Pig Pen Road (now Colebrook Road) near Ferry Farm in Stafford. After the business grew, he moved it to Kings Highway (Route 3, east) where this photograph was taken. (Janet Chinn LeCouteur.)

Liberty Hall was located near Berea. Dr. Michael Wallace acquired Liberty Hall and later gave it to his son, John. The house originally was a two-story, L-shaped log structure. The property had about 518 acres stretching from Truslow Road (State Route 652) near Enon Community Center to Potomac Run near Abel Lake before the house burned. The Wallace cemetery is northwest of the house site. (Daniel M. Chichester.)

George Skinner and his father, Benjamin, built this house in 1925, on the family's 20-acre farm on Cool Springs Road. George Skinner and his wife had nine children—four girls and five boys—who were born in the family home, which still stands. (Wayne Skinner.)

Known today as Lightner's Store or Lightner House, the brick structure was originally used as a warehouse by Basil Gordon. It was built about 1833 at 104 River Road (now considered to front on Cambridge Street) in Falmouth. Harry G. Lightner purchased the property in 1878 and converted the first floor into a country store, lunchroom, and ice cream parlor. The Lightner family used the second-floor as living quarters. (Shirley Heim.)

The building that housed Lightner's Store had a one-story clapboard structure attached to the south elevation, seen in the c. 1900 photograph above, that no longer stands. In the bottom photograph, "Geo. J. Lightner" is painted on the front edge of the porch roof. Coca-Cola was advertised for 5¢, and a wooden shipping box on the porch floor was stamped "Ivory Soap." The clapboard building on the left has a "Post Office, Falmouth, Va." sign above another sign that reads "Geo. S. Graninger." (Top: Shirley Heim; bottom: Belmont, the Gari Melchers Estate and Memorial Gallery, University of Mary Washington, Fredericksburg.)

"Bell Loute" was written on the back of this old photograph. Not much is known about the house or its location. Note the hammock made from barrel staves. This picture was found in Daniel M. Chichester's collection of old family photographs. (Daniel M. Chichester.)

Oakenwold dates to about 1850. John Moncure built Oakenwold for his daughter, Mary, and her husband, William A. Nelson. McCarty Chichester Moncure owned the property in 1947. (Daniel M. Chichester.)

The Temperance Hotel or Tavern was located at 121 Washington Street in Falmouth. It was originally built as a warehouse around 1815. The building was changed to an inn and tavern that welcomed stage travelers to the busy town. An 1884 deed listed the name as "the Falls Temperance House." The tavern building is now a private residence. (Belmont, the Gari Melchers Estate and Memorial Gallery, University of Mary Washington, Fredericksburg.)

Walnut Hill, located on the west side of State Route 644, was built around 1814. Nathaniel Greaves owned Walnut Hill before William and Charles Sterne purchased the property. Walnut Hill was one of the oldest working farms in Stafford County before it burned. (Joyce W. Sterne.)

The White Oak School on Route 218, at the intersection of Newton Road, is shown in this early photograph. The school for grades one through six originally had three rooms with two grades taught per room. The size of the building was increased and the exterior was bricked. Today it houses the White Oak Civil War Museum and Stafford Research Center. (Shirley Heim.)

The unidentified people in this c. 1900 photograph rode the train from Brooke to Widewater to attend a picnic there. (Eileen Shelton Greene.)

Seven
CREEKS AND RIVERS

The first five photographs in this chapter show Falmouth during the flood in October 1942. The water from the Rappahannock River reached to the second story on the buildings at the intersection of Washington Street and old U.S. Route 1 (now Cambridge Street) in Falmouth. Belmont is seen in the background in both these photographs. The building in the bottom right of this photograph now houses Cock-eye Cox's Seafood Market. (Belmont, the Gari Melchers Estate and Memorial Gallery, University of Mary Washington, Fredericksburg.)

Only the second floor of the Monroe and Berry's Grocery and the roof of Snell Esso Station are visible in this photograph. Most of the residents in the Falmouth bottom had to leave their homes during the flood. The steel truss bridge over the Rappahannock River (below) is nearly underwater as a result of the high water level. Concrete pillars already in place for the new bridge were a little late for the 1942 flood. Other floods in 1937, 1955, and 1972 also forced some of Falmouth's residents to temporarily move to higher ground. (Belmont, the Gari Melchers Estate and Memorial Gallery, University of Mary Washington, Fredericksburg.)

Water crested at 45 feet during October 1942. During the previous flood in 1937, the water crested at 40 feet. The building shown at right in the top photograph appears to have been partially lifted off its foundation by the floodwater. The Cambridge Inn building is half submerged by the floodwater. (Belmont, the Gari Melchers Estate and Memorial Gallery, University of Mary Washington, Fredericksburg.)

These undated photographs show a frozen Rappahannock River that has partially destroyed the Free (Falmouth) Bridge, which connected Stafford to Fredericksburg. Men walk across the frozen river to inspect the damage to the bridge during a cold winter around 1900. Belmont can be seen on the hill to the left in the top photograph. The Cambridge Inn is to the left of the bridge and the Gordon House is on the right in the bottom photograph. (Belmont, the Gari Melchers Estate and Memorial Gallery, University of Mary Washington, Fredericksburg.)

This undated photograph shows the Free Bridge across the Rappahannock River after a snow. Many bridges have spanned the river since George Washington crossed a wooden bridge in 1781 en route to Yorktown. Joseph B. Ficklen, former owner of Belmont, bought Falmouth Bridge from Elizabeth G. Dunbar in 1847. The bridge across the river before the early 1900s washed away in a flood; the replacement was partially destroyed when the river froze. The toll bridge was replaced by another Falmouth Bridge locally known as the Free Bridge. (Daniel M. Chichester.)

Robert "Bob" Harris stands in his rental boat holding the bass he caught. He owned Harris' Store and Wagon Yard in Fredericksburg. (White Oak Civil War Museum and Stafford Research Center.)

113

Archie and Gordon Newton, father and son, assess their crabbing equipment at Aqua-Po on the Potomac River at the end of the 1966 crabbing season. The Newton family have fished and crabbed the Potomac River and Potomac Creek for generations. (Margaret T. Scott.)

Archie Newton fishes his gill nets on the Potomac River for selling fish and for bait for his crab pots in this March 1966 photograph. (Margaret T. Scott.)

Jessie Newton holds a huge Rockfish caught on the Potomac River. (Raymond Newton and Denise Newton Hardy.)

Mr. Wood (left), Jessie Newton (center), and Mr. Webb hold a string of Rockfish in the 1940s. Wood and Webb traveled from Waynesboro to buy barrels of fish at 3¢ per pound. (Raymond Newton and Denise Newton Hardy.)

This undated photograph shows the abutments for the dam used for electric power plant on the Rappahannock River near present-day Normandy Village as seen from Fredericksburg to Stafford. (Daniel M. Chichester.)

Paul Scott (left), John Cowan, and David Scott are perched on this tree stump on Aquia Creek about 1951. Paul and John became attorneys. David Scott became a doctor. All three live in the Fredericksburg area. (Margaret T. Scott.)

Paul Scott found many Native American points and Civil War bullets on this shore near his family's summer cottage on Aquia Creek in the 1950s. Today little evidence remains to prove Aquia Creek Landing, at Aqua-Po Beach, was an important transportation terminus prior to, during, and after the Civil War. (Margaret T. Scott.)

Dr. David William Scott Jr. bought an old, double-ended, wooden navy lifeboat from Earl Broyles and fixed it up for his family's use. He rebuilt the 1932 Chevrolet engine in it and built a cabin with bunks below. They called their boat the *Yachet*. Scott, his wife, Margaret, and their three children enjoyed using their boat on the water near their cottage. This 1952 photograph shows the *Yachet* docked at the family's summer cottage, "the Cove," on Aquia Creek. Brooks' Point is seen at left and Aqua-Po Beach is at right in the background. (Margaret T. Scott.)

Dr. Scott posed for this photograph with his children, from left to right, Paul, David, and Peggy, on the bow and cabin of the *Yachet* in 1953. Paul remembers working with his brother David in the family garden, picking fruit in their orchard, and fishing their crab pots during the summers spent at the Cove. Paul and David were allowed to sell the excess vegetables and apples door to door and to food markets, including Earl's, to earn spending money. After they had finished their chores, they swam, fished, gigged for frogs, hunted for snakes, and went "eyeballing" for Civil War relics around Aqua-Po Beach. (Margaret T. Scott.)

In this 1952 photograph, Dr. Scott, his son David, and Thad Connally, Mary Washington hospital administrator, prepare for a fall trip down the Potomac River to fish for rockfish. Scott made many house calls to many families in Stafford before making house calls became impractical. Paul Scott remembers accompanying his father in a small boat Dr. Scott used to make house calls to the Uly Brooks family at Brooks' Point on Aquia Creek. While their father performed his medical service, Paul and his brother David took the opportunity to gather eggs and swim with Brooks's daughter, Janie. Dr. Scott was also a physician for the Stafford Girl Scout Camp located on Aquia Creek adjacent to Potter Payne's. (Margaret T. Scott.)

Raymond Sullivan's 1937 Ford sits near a fishing shanty just offshore at Belle Plains on Potomac Creek around 1943–1944. Some fishing shanties were used to store fishing equipment, motors, corks, and nets used by fishermen; others also had bunks and stoves for sleeping and cooking. (Rev. E. T. "Tick" Bourne.)

The Widewater shore meets the Potomac River near Brooks' Point in Stafford County in this c. 1900s photograph. The Widewater area of Stafford County boasts many of the oldest homes in the county: Richland, owned by the Brent family, Stafford's first English settlers; and Clifton, best known for the huge seine fishery and duck hunting there by U.S. presidents Grover Cleveland, Benjamin Harrison, and Theodore Roosevelt. Other properties in the area were West Farm Bloomington, Arkendale, Myrtle Grove, Palace Green, Edge Hill, and Rock Ramore. (Eileen Shelton Greene.)

The *Yachet* gave these boys plenty of adventures on the Potomac River and its tributaries in the 1950s. From left to right are Glendon Insley, Paul Scott, John Cowan, David Scott, Thomas Embrey, Johnny Westbrook, and William "Billy" Johnson. (Margaret T. Scott.)

Eight
STAFFORD'S CHANGING LANDSCAPE

AQUIA TAVERN—On Richmond-Washington Highway, 41 mi. south of Washington, (P. O., Stafford, Va.)

Aquia Tavern was located on Richmond-Washington Highway, 41 miles south of Washington, D.C., in Stafford. It was about 200 yards from historic Aquia Church and a mile from the old Catholic cemetery and shrine. Soldiers from Quantico came to the tavern for the dances that were held there. (Shenandoah Publishing House, Inc.; author's collection.)

Austin Farms Restaurant was located 12 miles north of Fredericksburg on U.S. Route 1 in Stafford. The building had awnings and a more colorful exterior in this postcard. A later postcard of Austin Farms Restaurant advertised that it was famous for fine food since 1926 and had a catering service. A later renovation put brick halfway up the exterior. The building was vacant for years after the restaurant closed. It was torn down in the 1990s. (H. H. Ahrens, Charlotte, North Carolina; author's collection.)

Brown's Tourist Camp evolved over many years. This postcard shows small and simple tourist cabins at the camp that advertised it as one of the finest tourist camps in Virginia, situated on No. 1 Highway, midway between Washington and Richmond, with homelike accommodations. The cottages were enlarged and remodeled several times. It became Brown's Court and eventually, the cottages were used as rentals. The large, two-story, brick main building was torn down in the 1990s. The small cabins were renovated into permanent dwellings and sold. (Author's collection.)

Earl's Food Market was a landmark at the intersection of Butler and White Oak Roads in the Chatham Heights area for decades. "Take a right (or left) at Earl's" was an essential phrase for anyone giving directions for the general vicinity. Some feared a number of travelers would get lost after the Route 218 underpass for RF&P Railroad was removed next to the landmark. Earl's Food Market, which had grown over the decades, converted to Earl's True Value Hardware in the 1990s. Earl Broyles owns the property, and his son, Wayne, operates the business. (Wayne Broyles.)

Elko Motor Lodge, located on U.S. Route 1, four miles north of Fredericksburg, Virginia, advertised "colonial brick cottages with private baths, circulating hot water heat, abundance of hot and cold water, excellent dining room, southern cuisine, Virginia ham, fried chicken, seafood dinners, snack bar, fountain, and gift shop." Zeke Ellis was the manager. (Henry H. Ahrens, publisher; author's collection.)

The Eskimo Diner, located eight miles north of Fredericksburg on U.S. Route 1, was a favorite of truck drivers as well as locals. Luther S. "Eskimo" Hodge, a well digger by trade, started the 24-hour restaurant, which advertised steaks, chops, and seafood, in 1929. (Photograph by author.)

Four Gables Restaurant and Auto Court advertised "chicken, steak, and Virginia ham dinners cooked to order, cabins and tourist home, a congenial place for congenial people, located two miles north of Fredericksburg, Virginia on U.S. Route No. 1." (C. H. Ruth, Washington, D.C.; author's collection.)

HOTEL VIRGINIA, STAFFORD, VA.

The Hotel Virginia building is located on U.S. Route 1, just south of Route 630. When it operated as a hotel, it was described as having "All modern Conveniences" and "Old Virginia Cooking." This postcard is postmarked November 24, 1930. The building that once housed Hotel Virginia and Hotel Stafford is now a real estate office. The building has changed very little, although its surroundings are greatly changed. (R. A. Kishpaugh, Fredericksburg; author's collection.)

Martin Sherwin Motor Court
Stafford, Va.

The Martin Sherwin Motor Court Highway Hotel was located 40 miles south of Washington, D.C., and 14 miles north of Fredericksburg on U.S. Highway 1, in Stafford County. The hotel was advertised as a new type of highway hotel that offered private baths throughout, completely insulated and sound proofed, oversized central heating, tasteful furnishings, and an excellent restaurant. This hotel was razed in recent years for new construction. (Tichnor Brothers, Inc., Boston; author's collection.)

Oak Grove Tourist Court, 4 miles North of Fredericksburg, Va. on U. S. Hwy No. 1.

Oak Grove Tourist Court, located four miles north of Fredericksburg on U.S. Highway 1 in the Falmouth area of Stafford, began operating in the 1940s. It advertised completely modern cottages, steam heat, and private baths. The gas station eventually closed, and the owners, Mr. and Mrs. A. A. Harrison, lived in the main building. It was a Stuckey's in the early 1950s. Eldridge Logan and his wife, Geraldine, purchased the property in 1978, and he operated an electrician business there. The cabins were later torn down. (C. H. Ruth, Washington, D.C.; author's collection.)

Roma Restaurant and Auto Court was located five miles north of Fredericksburg on U.S. Highway 1. This postcard advertised Italian food and select and completely modern cottages in pleasant surroundings. Paul Torrice operated the business. (C. H. Ruth, Washington, D.C.; author's collection.)

126

The Sportsman Motor Court, 7 miles North of Fredericksburg, Va. on U.S. Hwy No. 1

The Sportsman Motor Court was located 7 miles north of Fredericksburg and 43 miles south of Washington, D.C., on U.S. Route 1. It advertised large rooms with private baths, Simmons furnishings, modern central-heating, soundproof masonry walls, television, and unit-controlled air conditioning. The Sportsman Motor Court changed to Fredericksburg Motor Court and later to Bradshaw Motel. Today Bradshaw Motel is empty and vandalized. (C. H. Ruth, Washington, D.C; author's collection.)

Town and Country Motel was located in Falmouth on U.S. Highway 1, five miles north of Historic Fredericksburg in Stafford County. It advertised itself as "air conditioned, free television and telephone in every room, new and modern and a restaurant nearby." Mr. and Mrs. Oliver Perry owned and operated the motel. The motel complex is now a nursing home. (Brooks Photographers, Inc., Bethesda, Maryland; author's collection.)

The Traveler's Drive In Restaurant was located on U.S. Route 1, north of Fredericksburg. It advertised air-conditioning and excellent food in the 1950s. The building was razed for new construction. (MWM, publisher; author's collection.)

ABOUT THE AUTHOR

De'Onne Scott has lived in Stafford County since 1973. She has been a part-time docent at Belmont in Stafford, Virginia, for more than five years. Married, mother of two daughters, grandmother of two, and stepmother of two, she graduated from the University of Mary Washington in 1999 with a degree in historic preservation. Her many hobbies include doing historical research for family, friends, and local organizations.